Art and Narrative

Tzu Yu Allison Lin

· Acknowledgements ·

I would like to thank Mr Michael Song, the President of Showwe Publisher, Taipei. Without his encouragement and strong support, it would be impossible to have this book published. I also want to thank Cecilia Hsu. As the Chief Editor, Ms Hsu gave many important and professional suggestions during the process of my writing.

This book aims to be a guidance, showing a way of reading a literary text not only verbally but also visually. Through artistic terms and movements, the readers can see that a literary text can be enjoyed not only through the black words on the white

papers. A solid and profound understanding of the visual arts can especially remind us how different and also, how difficult, when it comes to read a verbal painting.

For scholars, students, and also for people who are interested in the mutual development of visual and verbal narrative forms, this book is also innovative. Through crossing the boundry, I sincerely hope that this research can make the readers to think about some fundamental questions such as 'what is art', and 'what is literature', as these questions can always inspire, and yet, challenge us.

Allison Lin

Faculty of Education

Gaziantep University

2019

· Preface ·

Prof Rachel Bowlby

John Keats's famous poem, 'Ode on a Grecian Urn', published in 1820, explores the suspension of ordinary time. It does this in two ways in particular. On the one hand, the scenes depicted on the ancient vessel, and described in the poem, remain paused at the same points in the narratives that they suggest. Youthful desire is not fulfilled (but at the same time it is never thwarted, and it is never over). On the other hand, the vase

itself remains as a real representative of an aesthetically prized culture from long ago. It is a solid object; it stands for ancient Greece. It always has done, and it always will.

Allison Lin's engaging and delicately detailed little book is also preoccupied with doubled images: especially those that, like Keats's poem, play on contrasts of loss and desire, of timelessness and temporal movement. In a certain way, Keats's poem—which lies outside Lin's book—could be said to form a template from which some later representations appear to take their different bearings; these differences then show up features that seem to be lacking, or at least not present, in the earlier work. I am thinking in particular of one of the poems that Lin cites in full, with a

subsequent commentary: Richard Aldington's 'Eros and Psyche'. In this poem there are two statues seen in the suburb of Camden Town. One is of 'Cobden', in commemoration of a nineteenth-century political figure, and the other, 'Eros and Psyche', alludes to ancient Greek culture in the same way as Keats's urn. The Greek statue is already relativised by its sharing of place with the representative of a particular moment in public history (but a moment that by now—by the time of the poem—has been more or less forgotten, since the speaker can't remember who Cobden was). Both are statues; neither has priority, is seen alone. This then draws attention to an artificial isolation of the urn in Keats. Although in reality urns like the one the poem describes were carefully preserved and displayed in museums—inclouding

London's British Museum, in the same city as the statues of Aldington's poem—that present-day situation, distant from its historical and geographical origins, is not a part of the 'Ode'.

In other ways too, Aldington draws attention to a different type of contrast from those that are shown by Keats. The statue of Eros and Psyche has suffered from the disfiguring effects of real time and real-world exposure. It is dirty, 'grimy', and so is the surrounding atmosphere. In Camden Town the pair of gods is *out of place.* The poem describes the tranquil, mythical setting which should be theirs instead. That is to say, it depicts a scene which is shown as positive in value (this is where the lovers ought to be, not here on this ugly street) but is also, in the

negative, a picture of what is *not*, is absent from the scene that the spectator observes.

The sense of disjunction in 'Eros and Psyche' is also explored through the situation of the speaker. Keats's poet, addressing a 'thou' with familiarity, is not situated in any specific place or time. But Aldington's is sitting on top of a double-decker bus; it is from this elevated but realistic vantage point, passing through the present day, that he sees the two artworks—and the other components of the local sights, its 'square of ugly sordid' shops' and its underground station.

Aldington might seem at first sight, in a Victorian way, to

be making a conventional kind of contrast between the beauties of classical civilisation and the sordid realities of the modern world; but that is not the case. Near the end of the poem, having drawn at length the picture of the perfect mythical place from which the present Eros and Psyche are separated, the speaker turns to one more world, this time the real conditions in which the statue would have been created. In this description, it is 'the limbs that a Greek slave cut / In some old Italian town'.

Jane Austen's novel *Pride and Prejudice*, another of the texts that Lin dissects, was published a few years before Keats's 'Ode'. It comes from the same country, and the same period, but generically it lays out somewhat different markers of its literary

world. Lin is interested in the novel's analysis of different perceptions of reality—beginning, in many senses of that word, with the novel's opening sentence which ironically sets up a 'truth' that is 'universally acknowledged'. In its questionable determinacy, this has something in common, thematically too, with the enigmatically categorical declaration at the end of Keats's poem, that 'Beauty is truth, truth beauty - that is all / Ye know on earth, and all ye need to know.'

Lin's own preferred version of realism leads her to focus on the portrait of Mr Darcy that hangs in Pemberley, his ancestral home. When Elizabeth Bennet is shown this image by an affectionate housekeeper, her previously negative judgement

of the man is seriously modified for the better: from now on she starts to see him, like his lovely home, as a possible object of love. And indeed this more benign picture—this *picture*— is what the novel's narrator, along with Elizabeth herself, will endorse as correct, as distinct from the more negative images of Darcy that have been visible up to this point. It's a nice example of realism for Lin to choose, given the pathway of her own book, which moves through the largely visual modes of imagism (or surrealism) and impressionism, and ends with symbolism. Lin's realism, in this instance, is not reality but a painting—a painting, that is, which is represented in a novel's description of it in words. It is through such pictures, such artistic representations, that real lives are lived—in all their poignant divisions and

rapprochements: between a here and an elsewhere, or between here and then and always. *Art and Narrative* offers many literary occasions for thinking about the challenging and ever changing connections and disconnections of truth and beauty in their times and in their texts.

16 May, 2019

Rachel Bowlby

Professor of Comparative Literature,

University College London

Author, most recently,

of *Talking Walking* and *Everyday Stories*

Art and Narrative

· Contents ·

· Chapter 1 ·

Surrealism

Through reading Walter Benjamin's critical essay, 'Surrealism: The Last Snapshot of the European Intelligentsia', I would like to trace the key point of Surrealist aesthetics, particularly the juxtapositions of visual objects in the city of London. Richard Aldington's two poems, *London (May 1915)* and *Eros and Psyche,* come to depict Surrealist image spheres, as their visual representations in words would show. The dialectical

optic of the poet comes to reveal an allegorical synthesis, giving birth to new meanings. The city of London shows the irrational fusion of the opposites, in a way which a Surrealist reading of these two poems is able to construct a critical virtue.

Introduction

The aim of this research is not to claim that Richard Aldington should be catagorised as a Surrealist poet; nor his poems are specifically Surrealist. Rather, I want to show the possibilities of reading two of Aldington's poems: *London (May 1915)* and *Eros and Psyche* through a Surrealist perspective. Focusing on visual

objects, love and allegory, Aldington's two poems can be read in terms of the way in which images and colours come to form a dream-like cityscape of London.

Object

A city is a dialectic representation of love. In London, love can be understood as 'a dream-like image', as in 'a surreal illusion of love, which stays in the viewer's mind as a poem of colours, representing eternity' (Lin 1). In Walter Benjamin's 'Surrealism: The Last Snapshot of the European Intelligentsia', the reader can see that this representation of love comes in several forms, in the

Surrealist montage: dream, mémoire involontaire, desire, and visual objects. All elements in a city, no matter the subjective one or the objective one, the inner aspect or the outer aspect, under the form of Surrealist aesthetics, for Benjamin, come to show a collective 'humanistic concept of freedom' (Benjamin 177).

Nevertheless, as J. H. Matthews has pointed out that the English Surrealists 'show their close alliance with surrealism in France' (Matthews 59), just as Breton keeps his admiration to M G Lewis and the English 'Gothic novels' (Matthews 57). In writing, Surrealism can be defined as such, representing 'psychic automatism in its pure state, by which one proposes to express - verbally, by means of the written word, or in any other manner - the actual functioning of thought', as the reader can see in the

Manifesto of Surrealism, when André Breton published it in Paris, in 1924 (Woodruff 191, and Matthews, 'Fifty Years Later' 1). The free association of visual objects - no matter how striking the visual or the verbal images would be - the Surrealist perspective somehow comes to show the readers a method of artistic and literary creation, in a way which the visible objects can be twisted, juxtaposed, and re-represented, in order to construct an imaginary world of fancy. In poetry, specifically, as Nicholas Calas has observed that this imaginary world of fancy can be revealed, as the poet's 'disorderly passion' comes to give a 'greater freedom' (Glicksberg 303) to poetic writings. The disorderly passion is inspired by love, indicating an unconscious desire, in a way which deep emotions are aroused. The visual

and the verbal representations of this 'bizarre imaginative effect' (Baldick 324) - in a surreal sense - come to depict a romantic transition between the present and 'a remote, primordial past' (Glicksberg 303), as the readers can see in Aldington's two poems.

Indeed, the psychological and intuitive motifs of Surrealism come to show the readers a way in which the oppressed can be released, as Surrealist aesthetics can be understood as a form of representing 'an absolute reality' - 'a *surreality*' (Wolin 97). The juxtaposition of visual objects is the key for the dialectical moment to happen, embracing each visual object even when it is out of its own original cultural context, as the new meaning emerges. In this respect, in semiotic terms, a visual object contents not only its 'informational' (Barthes, 'The Third

Meaning' 52) meaning - on the first level. Rather, the very visual object serves as a symbol, on the second level, as 'the signifier' (Barthes, 'The Third Meaning' 53). It should have a new meaning to be read, in a way which it is not what it is signified, as Barthes called it, 'a poetical grasp' - on the third level (Barthes, 'The Third Meaning' 53).

Love

In Richard Aldington's London poem, *Eros and Psyche*, the readers can see that the statue of Eros and Psyche is a good example, which comes to show a kind of 'poetical grasp', in

Roland Barthes's term. It is worth it to read the whole poem:

Eros and Psyche

In an old dull yard near Camden Town,

Which echoes with the rattle of cars and 'buses

And freight-trains, puffing steam and smoke and dirt

To the steaming sooty sky -

There stands an old and grimy statue,

A statue of Psyche and her lover, Eros.

A little nearer Camden Town,

In a square of ugly sordid shops,

Is another statue, facing the Tube,

Staring with heavy purposeless glare

At the red and white shining tiles -

A tall stone statue of Cobden.

And though no one ever pauses to see

What hero it is that faces the Tube,

I can understand very well indeed

That England must honour its national heroes,

Must honour the hero of Free Trade -

Or was it the Corn Laws? -

That I can understand.

But what I shall never understand

Is the little group in the dingy yard

Under the dingier sky,

The Eros and Psyche -

Surrounded with pots and terra-cotta busts

And urns and broken pillars -

Eros, naked, with his wings stretched out

Just lighting down to kiss her on the lips.

What are they doing here in Camden Town

In the midst of all this clamour and filth?

They, who should stand in a sun-lit room

Hung with deep purple, painted with gods,

Paved with dark porphyry,

Stand for ever embraced

By the side of a rustling fountain

Over a marble basin

Carved with leopards and grapes and young men
dancing;

Or in a garden leaning above Corinth,

Under the ilexes and the cypresses,

Very white against a very blue sky;

Or growing hoary, if they must grow old,

With lichens and softly creeping moss:

What are they doing here in Camden Town?

And who has brought their naked beauty

And their young fresh lust to Camden Town,

Which settled long ago to toil and sweat and filth,

Forgetting - to the greater glory of Free Trade -

Young beauty and young love and youthful flesh?

Slowly the rain settles down on them,

Slowly the soot eats into them,

Slowly the stone grows greyer and dirtier,

Till in spite of his spreading wings

Her eyes have a rim of soot

Half an inch deep,

And his wings, the tall god's wings,

That should be red and silver

Are ocherous brown.

And I peer from a 'bus-top

As we splash through the grease and puddles,

And I glimpse them, huddled against the wall,

Half-hidden under a freight-train's smoke,

And I see the limbs that a Greek slave cut

In some old Italian town,

I see them growing older

And sadder

And greyer.

(Ford 525-526)

In this poem, the dialectical optic of the poet comes to reveal a Surrealist effect, as the montage of different visual objects would show: old statue verses the shinning one, England national hero verses Greek mythology, the honourable verses the dingy, the glory Free Trade verses the filthy London reality. The statue of Eros and Psyche represents the '*punctum*' (Barthes 47), in a way which a visual object comes to disturb the critics, to make him and her 'dream' (Barthes 49). The statue itself, among other visual objects in London, as the viewer comes to 'peer' (Ford 526) from the top of a double-decker London bus, is that special '*something*' (Barthes 49), which has a Greek origin - a past which comes to refuse all signs of the viewer's cultural present, as London Camden Town can be represented by an 'old dull yard', with some 'ugly sordid

shops' in it, near a Tube station.

As Barthes claims, in his *Camera Lucida*, the '*studium* is ultimately always coded' (Barthes 51). The statue of Eros and Psyche also has its own original cultural meaning, in its own context. And yet, in London, the statue can be read as a Surrealist appeal, as Eros and Psyche should be '[b]y the side of a rustling fountain / Over a marble basin / Carved with leopards and grapes and young men dancing' (Ford 526). Eros and Psyche should be in its own cultural context, just like the 'tall stone statue of Cobden' (Ford 525), in its own cultural context in London, as a national hero - although 'no one ever pauses to see' (Ford 525).

And yet, in the poem, there are two images come to suggest the original meaning of the statue which are deconstructed by

the same question, asked twice by the viewer:

> What are they doing here in Camden Town
>
> In the midst of all this clamour and filth?
>
> […]
>
> Or growing hoary, if they must grow old,
>
> With lichens and softly creeping moss:
>
> What are they doing here in Camden Town?
>
> (Ford 525-526)

'They' - Eros and Psyche, because of these two questions, immediately, become the *'punctum'* in Barthes's term. They should be in their own cultural context, as in the viewer's dream-

like image. Eros and Psyche 'should stand in a sun-lit room /

[…] / Stand for ever embraced' (Ford 525). However, in London

Camden Town, they are the '*punctum*', because they are not '[b]

y the side of a rustling fountain / Over a marble basin / Carved

with leopards and grapes and young men dancing' (Ford 526). In

London Camden Town, their young love and young flesh, for the

viewer, are like the 'essence (of a wound)' (Barthes 49), teasing

the viewer's feeling.

 As the critical viewer sees in Camden Town, among all

other visual objects, the statue of Eros and Psyche reminds the

viewer the 'sweat and filth' of London's reality. It is a cityscape

of commodity, Free Trade, and the national hero's 'tall stone

statue' - standing there, in red and white, 'shinning' (Ford

525). In reality, the viewer can only see the statue of Eros and Psyche shows, as a part of Camden Town, covered by 'a rim of soot', and eaten 'softly' by the 'creeping moss' (Ford 526). The statue of *Eros and Psyche*, in London, is ironically freed from its past, its once-upon-a-time, as we come to understand Benjamin's concept of 'the historical object-world' (Steinberg 92). Aldington's dialectical optic is able to see the statue of Eros and Psyche, *once*, the 'heroic' object, juxtaposing among the 'ordinary' (Scott 131) London visual objects - such as shops and commodities. The statue, again, implies that love in London is somehow visually represented as some erotica, which is located within the conscious materialist practice.

Allegory

In the poem, the Surrealist status of the statue, Eros and Psyche, comes to reveal the reality of 'sweat and filth' (Ford 526) of London Camden Town. 'Free Trade', modernization, urbanization - all visual objects of the social milieu come to indicate the degeneration of love - from Greek mythology to 'Greek slave' (Ford 526), from the aura of love and the beauty of a work of art, as the statue itself once represented, to a skindeep kind of 'young fresh lust' and 'youthful flesh' (Ford 526). The young lust and young flesh can be visualized as in Walter

Sickert's sketch, *Study for L'Affaire de Camden Town* (1909, in Robins 67), as the woman's naked body under the gaze would show.

The 'Greek slave cut' that the poet sees on the 'limbs' (Ford 526), comes to remind the viewer the statues of a pure commodity of a female body, as Jean Léon Gérôme's *Roman Slave Market* (1884, in Higonnet 407) would show. The lover's 'naked beauty' becomes 'young flesh lust' (Ford 526) in London Camden Town, indicating a 'profane illumination' (Woodruff 198) of the city. The word 'lust', in the poem, reveals a pure sexual desire. As in Breton's Paris, in his novel *Nadja*, one can see that 'man and woman indifferently continue making love' (qtd. in Woodruff 198). Lust, in a sexual way, is an attitude of

being indifference, as the female body is commodified, which is exchangeable, in the urban market.

If we read the statue of Eros and Psyche as a visual representation of love, even it is a sad one, as the ending of the poem suggests, somehow, in the context of London Camden Town, it has an allegorical meaning. As the viewer's gaze shows, the passion in the city is more visual rather than verbal. Through reading Baudelaire, Benjamin also reveals the way of seeing salvation and redemption via the ruination of the poetic object. In Aldington's poem, as the reader can see that the statue - the poetic object itself - is 'slowly' (Ford 526) eaten by the rain and the soot, becoming dirtier, in a colour of 'ocherous brown' (Ford 526). The dialectical optic transforms the poet's London

into a dialectical moment, in a way which the spatial and the temporal gaps are gone, as Eros's 'tall god's wings' lose their 'red and silver' colour, Psyche's eyes 'have a rim of soot' (Ford 526). All visual objects and their meanings are crumbled in this dream-like image sphere, as they are commodified, and getting weaker. London, at this point, is 'a site overlaid with myth and peopled with unrecognized sphinxes', in Aragon's words (Abbas 48). *Eros and Psyche* can be read as the London experience of Benjamin's phantasmagoria. The overwhelming juxtaposition of the modern and the premodern is sad and grey, because one can see the disappearing aura of a work of art is the image of the shock. Somehow, the ugly shops are the visual representations of the new and the now - indicating the modern myth of progress.

The question of 'What are they doing here in Camden Town?' somehow represents the tension of modernity in the city, in a way which the nowness of the Tube station and the ugliness of the shops come together with the ancient Eros and Psyche statue, creating a kind of shock. As the bus passing, the visual image of the statue becomes blur, '[h]alf-hidden under a freight-train's smoke' (Ford 526). At this very moment, the viewer seems to have a dream-like image, representing the visual form of the statue. We are not sure whether this image is a dream, or an illusion, or a memory, as the viewer sees 'the limbs that a Greek slave cut / In some old Italian town' - Eros and Psyche seem to become 'older', 'sadder' and 'greyer' (Ford 526). Here, the salvation and redemption of the visual image seem to come

from a dialectical moment of revelation, as the viewer's present is engaged to an illusionary past, as the statue of Eros and Psyche loses its ancient mythological meaning. They are, indeed, just like a normal human couple who share a common human fate - to grow old together, and to die.

In the poem *London (May 1915)*, the reader can see that the city of London is visually represented as the dialectical moment of dream and allegory, when day comes to synthesize with night, 'dingy' with 'white', the ancient comes to inspire the present, when 'ruins' come to exist with the myth of urbanization - mess production, industrialization, and 'chimneys' (Ford 523). Through Surrealist visual representations, love comes to transit the past and the present, bringing beauty and ecstacy. Now we

read the poem:

London (May, 1915)

Glittering leaves

Dance in a squall;

Behind them bleak immoveable clouds.

A church spire

Holds up a little brass cock

To peck at the blue wheat fields.

Roofs, conical spires, tapering chimneys,

Livid with sunlight, lace the horizon.

A pear-tree, a broken white pyramid

In a dingy garden, troubles me

With ecstasy.

At night, the moon, a pregnant woman,

Walks cautiously over the slippery heavens

And I am tormented,

Obsessed,

Among all this beauty,

With a vision of ruins,

Of walls crumbling into clay.

(Ford 523)

The Surrealist perspective reveals the dialectical optic, in a way which the reality of a city is viewed as a dream, a world of 'monumental ruins' (Abbas 48). The city of London represents the dialectical moment of dream and allegory, when the poet's visual ecstacy comes to 'trouble' him (Ford 523). In Benjamin's 'Surrealism' essay, the reader can see that the intensity of the sensual experience towards 'a mystical beloved' (Benjamin 181) somehow becomes the very energy of revolution, in a 'world of things' (Benjamin 182), in terms of Surrealist visual and verbal representations. The 'broken write pyramid' in 'a dingy garden'

in the day time ('[l[ivid with sunlight') comes to juxtapose with the image of the night - 'the moon' and the walk of 'a pregnant woman' (Ford 523). In the Surrealist aesthetic sense, the walk of the pregnant woman in the night time indicates a desire of creation, coming from the unconscious, in the darkness, in the dream. The vision of heaven, representing in London, at this dialectical moment, has an allegorical meaning of beauty and love, even it is found in 'ruins / Of walls crumbling into clay' (Ford 523). The calling and the envision of a 'rebirth' (Buck-Morss 255) of the ancient ruins, on the dream level, reveal a subversive creative power over the 'systematic rationalization' (Buck-Morss 254) of the industrial city of London.

Conclusion

In the *London* poem, the viewer's 'allegorical gaze' (Gilloch
137) sees meanings out of the white pyramid in the garden, and
a pregnant woman walking in the night. In *Eros and Psyche* also,
the 'I' has a view, looking out from a London bus, which frames
the moment of the visual. As the aesthetics of Surrealism would
suggest, the juxtaposition of different visual objects, such as the
'tall stone statue' of the national hero on the street of London,
together with shops and the Tube, comes to show the subversive
meaning of the out-of-context statue: Psyche and her lover, Eros.

The statue of Eros and Psyche in *Eros and Psyche*, together with the white pyramid in *London*, come to represent the *punctum*, in Roland Barthes's term, in a way which they both deconstruct the existing cityscape of London - 'dingy', 'clamour', 'filth', and 'lust'. The viewer, with his allegorical optic, perceives the dialectical moment, as in a snapshot, which comes to synthesize the opposites in the world of visual objects.

Works Cited

Abbas, Ackbar. 'On Fascination: Walter Benjamin's Images'. *New German Critique* 48 (1989): 43 - 62.

Barthes, Roland. *Camera Lucida*. London: Vintage, 1993.

---. 'The Third Meaning'. *Image Music Text*. Trans. Stephen Heath. New York: Hill and Wang, 1997.

Benjamin, Walter. 'Surrealism: The Last Snapshot of the European Intelligentsia'. *Reflections*. Trans. Edmund Jephcott. New York: Schocken, 1986.

Ford, Mark, ed. *London: A History in Verse*. Cambridge, MA: Harvard University Press, 2012.

Gilloch, Graeme. *Myth and Metropolis: Walter Benjamin and the City.* Cambridge: Polity, 1997.

Glicksberg, Charles I. 'The Poetry of Surrealism'. *Prairie Schooner* 23.3 (1949): 302 - 313.

Higonnet, Patrice, Anne and Margaret. 'Façades: Walter Benjamin's Paris'. *Critical Inquiry* 10.3 (1984): 391 - 419.

Lin, Tzu Yu Allison. *London Poetics.* Taipei: Showwe, 2016.

Matthews, J. H. 'Surrealism and England'. *Comparative Literature Studies* 1.1 (1964): 55 - 72.

---. 'Fifty Years Later: *The Manifesto of Surrealism'. Twentieth Century Literature* 21.1 (1975): 1 - 9.

Morss-Buck, Susan. *The Dialectics of Seeing: Walter Benjamin and the Arcade Project.* Cambridge, MA: 1999.

Robins, Anna Gruetzner. *Walter Sickert: Drawings.* Hants: Scolar, 1996.

Scott, Clive. 'Street Photography: the Appropriateness of Language and an Appropriate Language'. *Street Photography: from Atget to Cartier-Bresson.* London: I. B. Tauris, 2007.

Steinberg, Michael P, ed. *Walter Benjamin and the Demands of History.* Ithaca: Cornell University Press, 1996.

'Surrealism'. *Oxford Dictionary of Literary Terms.* Chris Baldick. 3rd ed. 2008.

Wolin, Richard. 'Benjamin, Adorno, Surrealism'. *The Semblance of Subjectivity.* Tom Huhn and Lambert Zuidervaart, eds. Cambridge, MA: MIT, 1997.

Woodruff, Adam. 'The Shape of a City: Recollection in Benjamin's
A Berlin Chronicle and Breton's *Nadja'. Journal of Narrative
Theory* 33.2 (2003): 184 - 206.

· Chapter 2 ·

Impressionism

In this chapter, I want to theorise the dialectical images of London as signs, by using an Impressionist way of reading the visual and the verbal representations. Through reading three poems of London: William Wordsworth's 'Composed Upon Westminster Bridge, September 3, 1802', Oscar Wilde's 'Impression du Matin', and Carol Ann Duffy's 'Woman Seated in the Underground, 1941', I intend to show an awareness of the Impressionist narrative

technique in terms of the spatial representations of the city. The impressions - in both visual and verbal terms, come to show the way in which London is a gendered space, synthesising masculine and feminine metaphors into a sequence of unique narrations. Each moment represents a personal, a specific, and a dramatic London, which is depicted in colours, shapes, lines and emotions.

Introduction

The aim of this research is to show the way in which metaphors and signs of the urban space come to construct visual impressions, revealing through three poems about London.

Each one of them can be read seperately. And yet, the visual and verbal images in the poems come to indicate a coherent image of the city of London, bringing out a personal sensibility of this particular urban space.

William Wordsworth and the Impressive Sublime

William Wordsworth, in his poem, 'Composed Upon Westminster Bridge, September 3, 1802', brings the reader into a world of the Impressionist London. The specific date, month and year come to remind us (although Wordsworth himself would

not be aware of that) the way in which the French painter Claude

Monet used to paint his *Haystacks*, in different times of a day, or,

during several particular hours of a season.

Monet's *Impression, Sunrise* (1873) is considered as a work

of art, which is ground-breaking. It is not because Monet painted

something specifically beautiful. In fact, quite the opposite, it is

because of the ugliness of the painting. It is ugly, because it does not

represent a traditional academic way of looking at visual objects.

As Belinda Thomson pointed out, in several reviews, for example,

in *La Patrie*, or in *Le Charivari*, Monet's 'impression' in painting is

only considered as a sort of 'distorted' reality (Thomson 125), which

looks like an unfinished and an immature experiment. The audience

and the critics of Monet's time found that it is difficult to digest his

way of depicting an impression - especially when they saw on his canvas - those broken strokes, quick brushes, bright, sharp and vivid colours, and the blurred industrial background, which makes the whole thing look extremely untidy and dirty.

And yet, just because of this way of painting, Monet explores his way of expressing his own impression of a particular time, in a specific day. His impression has been put on his canvas, as a kind of memory found by the painter, in his own studio. I would argue, before Monet's painting, Wordsworth's impression of London, which is lingering on a very special moment in the morning, on Westminster Bridge, on a specific day, comes to show the readers a sense of an impressive sublime.

Composed Upon Westminster Bridge, September 3, 1802

Earth has not anything to show more fair:

Dull would he be of soul who could pass by

A sight so touching in its majesty;

This City now doth, like a garment, wear

The beauty of the morning: silent, bare,

Ships, towers, domes, theatres, and temples lie

Open unto the fields, and to the sky;

All bright and glittering in the smokeless air.

Never did sun more beautifully steep

In his first splendor, valley, rock, or hill;

Ne'er saw I, never felt, a calm so deep!

The river glideth at his own sweet will:

Dear God! the very houses seem asleep;

And all that mighty heart is lying still! (Ford 331)

The phrase 'Dear God!' expresses the gratitude - the need to thank God for the impressive sublime that Wordsworth felt in London, at that specific moment of September 3, 1802. The beauty of London comes to the eye of its beholder, so stunning, as Wordsworth could not find anything 'more fair' in this world. If there is someone, whose soul is not touched by what he or she sees in that morning of London ('A sight so touching in its majesty'), it means that he or she must be extremely '[d]ull'. This 'sight' is a visual impression, showing the power and the greatness of London

- as one sees a kind of 'quality of awesome' (Baldick 321), in a way which one's thought and soul can be lifted.

London is, in the eye of its beholder, like a Queen, 'silent', fresh and innocent, who 'wear[s]' a beautiful morning light. This light opens the eyes of the beholder, making him or her feel the beauty of London through '[s]hips, towers, domes, theatres, and temples'. Looking at 'the fields' and 'the sky', the viewer can see that the morning air is very 'bright' and clear ('smokeless', unlike Monet's grey and black industrial background on the canvas). This impressive sublime, created by the bright morning light - the sun, comes to make the viewer 'I' feel 'a calm so deep!' - a visual impression which makes one feel profoundly touched, as 'Never' before, in four negativities (the 'Earth has not', 'Never did sun',

'Ne'er saw I, never felt'); as 'the mighty heart is lying still' - as the view itself is so breathtaking - in a way that it is so occupied, 'so entirely filled with' (Day 184) the beauty of London.

Wordsworth's verbal impression is a sunlight effect, which comes way before the French Impressionism was known. And yet, Wordsworth did not concentrate on the depiction of visual realities - for example, the colour, the shape or the line of 'the river' Thames, the '[s]hips, towers, domes, theatres, and temples', 'the fields' and 'the sky'. Instead, he made the viewers see the beauty of London through the light, as the city was soaked in the sunlight in a way which that particular morning still comes to touch our soul, as we are reading this poem now. It is a light, which does not have the heat of the Summer. It is

also not a light, which shines as the way of the noon time. That morning light of beauty, as Wordsworth saw it, was only bright enough, to make the narrator see things, people and objects in London in a way of appreciation, as the phrase 'Dear God' indicates the 'virtue' and the 'dignity' (Hartman 126) of the inwardness of a human being in Wordsworth's sense.

Oscar Wilde and London Impressions

Impressions du Matin

The Thames nocturne of blue and gold

Changed to a Harmony in grey:

A barge with ochre-coloured hay

Dropped from the wharf: and chill and cold

The yellow fog came creeping down

The bridges, till the houses' walls

Seemed changed to shadows, and St. Paul's

Loomed like a bubble o'er the town.

Then suddenly arose the clang

Of waking life; the streets were stirred

With country wagons and a bird

Flew to the glistening roofs and sang.

But one pale woman all along,

The daylight kissing her wan hair,

Loitered beneath the gas lamps' flare,

With lips of flame and heart of stone. (Ford 452)

In four stanzas, Oscar Wilde shows the reader the way in which the city of London is seen from a far, a general view in the first stanza. That view, again, comes nearer and nearer to our views, stanza by stanza. Firstly, it was the night, as the colours 'blue and gold' shown. The street lamps come to reflect on the Thames, like 'a Harmony in grey', as the colour comes to represent an unclear view of the Thames in a 'chill and cold' atmosphere.

In the second stanza, although the 'yellow fog' comes ('creeping down') to cover the visible world of London, the narrator, in a way, can see even clearer, for the visual objects are vivid and are slowly becoming more specific to the view - 'the bridges', 'the houses' walls', 'and St. Paul's / Loomed like a bubble o'er the town'.

In the third stanza, we can see that the London scene becomes even more into details, as if we are a part of it. People are waking up, as if we can see them, and can hear 'the clang'; can see the bird on the roof and hear its song. The street of London is getting busier and busier, when the day begins, as people make noises and their activities make London streets a crowded space. For example, the morning traffic

('country waggons') on the street comes to change the previous harmonious grey atmosphere into a different mood.

In the fourth stanza, the narrator again, zooms in, bringing our visual focus to 'one pale woman all alone'. She is the sign of the dialectical aesthetics of London, coming to be the opposite pole of all those people as the crowd, with their activities, noises - as she is 'alone' and silent. The narrator wants us to see this woman, as if all the Impressionist way of depicting London in the previous three stanzas has only one function, which is just to make the viewers ready to see this woman. Although the sun is 'kissing' her, and yet, her hair is wet, her heart is cold (like a 'stone'). She is wondering around, aimlessly, under 'the gas lamps' fire' - even her lips seem to be as red as a flame,

her action, as far as we can see from the narrator's eye, is meaningless and without any passion or feeling.

What is going on here? All these Impressionist sensations of London in Wilde's poem cannot bring this woman to feel. This woman, although nameless, comes to remind me a painting of Édouard Manet's, *Olympia* (1863, in Smith 48). In the painting, Olympia is a posed, naked figure, waiting for 'her client' (Smith 49). There is a contrast between her facial expression and her inner feeling. Although she looks very calm in the painting, as Paul Smith pointed out, her 'locket' shows that 'she loves someone' (Smith 50). Again, as Smith suggested, 'any sex she might have with us is purely and simply for the money' (Smith 50). In other words, Olympia is able to do the business, without

feeling a thing, simply because we are not the one in her heart -
as in her locket. There is no confusion between her inner world
and the external reality.

Another painting of Manet's also comes to indicate a very
similar dialectical relation between the outer space (what people
can see) and the inner space (which is invisible to the others).
Although the barmaid is all dressed up, as if she is ready to serve
her clients, there is something in her eyes, which comes to show
a feeling of 'melancholic' (Smith 54). In Monat's *A Bar at the
Folies-Bergère* (1882, in Smith 53), she is a barmaid - that is
her profession. And yet, because of the emotions in her eyes, we
know that she is not, at least, heartless. The contrasts between
the inwardness and the public space, as the authors would argue,

illuminate 'the psychological effects' (Rubin 83) of Manet's visual sensations, as all the colours, lines and the visible cannot cover the barmaid named 'Suzon' (Rubin 83), and her emotion.

Through reading two women in Manet's paintings - Olympia and Suzon, the viewers can see the dialectical aesthetics of the inner and the outer spaces, for the psychological tensions these two women show us. Somehow, this poor nameless woman in Wilde's poem is just a visual representation, like all other visual objects in London, such as a bridge or a wall (even the Cathedral has a name, 'St. Paul'), as Wilde wrote her this way. Even she is kissed by the sun, surrounded by all colours and sensations of that very London morning, still, she gives us the dialectical aesthetics of London in the poetic form. As she

is incapable of feeling a thing, she is the sign of a total 'visual pleasure' (Olin 209). In other words, she can be anyone's 'imaginary possession' (Pollock 53), which can be identified with any other visual objects in London, under the gaze of the narrator and the viewers, as the richness of the external visible world comes to be the opposite of her internal world.

Carol Ann Duffy: A Woman in London

Although there is no date, nor month, Carol Ann Duffy's poem, 'Woman Seated in the Underground, 1941 *after the drawing by Henry Moore*', in many ways, reminds in the reader Wordsworth's

London, as the authors mentioned in the first section of this paper. When we juxtapose Duffy's poem and Wordsworth's, the readers can see the way in which these two poems represent the dialectical image of London, synthesising the positive and the negative emotions, the inner and the outer spaces.

In Wordsworth's poem, the city of London is represented as a Queen - who is quiet, fresh, and beautiful. With the effect of the morning sunlight, the narrator has the impressive sublime, feeling peaceful, calm, and thanking God for bringing him the beauty which he had never seen before. And yet, in Duffy's London, the reader can see that the narrator is a woman. She somehow represents a sense of nothingness in London.

The narrator 'I', this woman, is again, a nameless one ('I

know I am pregnant, but I do not know my name'), just like the one we see in Oscar Wilde's poem. Everything seems to be lost in the Second World War - memory, love, a family ('Someone / is looking for me even now), a place to live, a possible wedding ring, a handbag. At the end, she seems to us, is both physically and mentally lost in the crowd. The readers do not know anything about her - her name, her identity, her background. Her phrase 'Dear God' is not a gratitude to the beauty of London, as in Wordsworth's narrator shows us. On the contrary, it is a cry, which is trying to recall a lost soul.

Woman Seated in the Underground, 1941
after the drawing by Henry Moore

I forgot. I have looked at the other faces and found

No memory, no love. *Christ, she's a rum one.*

Their laughter fills the tunnel, but it does not

comfort me. There was a bang and then

I was running with the rest through smoke. Thick, grey

smoke has covered thirty years at least

I know I am pregnant, but I do not know my name.

Now they are singing. *Underneath the lantern*

by the barrack gate. But waiting for whom?

Did I? I have no wedding ring, no handbag, nothing.

I want a fag. I have either lost my ring or I am

A loose woman. No. Someone has loved me. Someone

is looking for me even now. I live somewhere.

I sing the word *darling* and it yields nothing.

Nothing. A child is crying. Mine doesn't show yet.

Baby. My hands mime the memory of knitting.

Purl. Plain. I know how to do these things, yet my mind

has unravelled into thin threads that lead nowhere.

In a moment I shall stand up and scream until

somebody helps me. The skies were filled with sirens, planes,

fire, bombs, and I lost myself in the crowd. Dear God.

(Ford 690)

Duffy's poem is like an elegy. In this poem, the readers can see that London Underground is a space. It comes to represent 'the violence of death and the fears associated with it', as one can see in 'ruins' (Scott 167). People tried to hide away from 'sirens, planes, fire, bombs'. As Clive Scott phrases it, apart from death, there are some 'other kinds of loss: national pride, social solidarity, self-belief' (Scott 167).

The crowd was noisy, as the narrator overheard 'their laughter' and their 'singing'. However, all these sensations only represent something as empty. Even the narrator's own singing, for instance, 'the word *darling*', comes to reveal 'nothing'. In the poem, the reader cannot see any vivid poetic motives or impressions. There is no sign of any quality of aesthetic beauty,

or, 'involuntary memory' (*mémoire involontaire*, in Nägele 128), because the narrator seems to have nothing to remember, or, she simply cannot remember anything which happened before the war. Although her baby was not born, she started imaging herself to be a mother. And yet, her hands are only imitating someone else's 'memory of knitting', as she does not have one.

With Henry Moore's drawing, the readers can identify Duffy's poem with another kind of sublime, in a way which the sense of beauty - the way one feels spiritually lifting, as in Wordsworth's impressionist sublime - does not come from pleasant sensory experiences. On the contrary, in the poem, this woman in the London Underground shows the reader the way in which the experience of the sublime is aroused 'by pain

and terror' (Day 183), with a kind of 'hellish' and 'visionary

significance' (Spalding 139). The image of this woman in

London comes to represent a binary pole, which is on the

opposite side of William Wordsworth's, forming a dialectical

aesthetics of the city of London.

In Wordsworth's poem, as Allison Lin claimed in her book

London Poetics, the reader can see that

'[t]he poet's inner self, his soul, comes to identify with

London, seeing the city as a representation of the essence

of a majestic grace (nature, the Sun) and a cultural power

(in different architectural forms), which touches and

moves the poet's soul. The city of London here, is a great

inspiration, which reinforces the poet's subjectivity [...] (Lin 77 - 78).

London is represented as a feminine sign, under the gaze of the male poet. The narrator sees her as a Muse, 'a great inspiration', which makes his soul calm, so that he is able to write about his impressive sublime. And yet, Duffy's woman, as one can see in several Moore's drawings, comes to show a chaotic and somehow, a ruined city. Although this nameless woman is also trying to think, to remember. However, the city of London does not come to her as a representation of peace and calm. Some drawing of Henry Moore can visualise this point for us. Moore's *Study for 'Group of Shelterers during an Air Raid' 1940-41*

(Tolson 28) shows a group of faceless tube shelterers, sitting together as injured figures. They seem without any hope, without any past, and only with an unknown future.

Duffy does not write about a 'smokeless', a clear picture of London, as in Wordsworth's poem. The readers can only see the dark, smoky, and dirty lines which come to construct the group of human figures, in a tunnel, as if there is no way out. The authors would argue that Duffy's narrator is more like a 'prayer' (Bloom 138), when we consider her phrase 'Dear God' as a dialectical pole of Wordsworth's. The woman somehow prays, at the end of the poem. Her 'Dear God' indicates more heavy weights of life, and the burden of survival.

Conclusion

The dialectical aesthetics of London illuminate not only aesthetics questions about Impressionism, but also the way in which those aesthetic issues of Impressionist techniques were determined and conditioned by gender and spatial concerns, in the urban context of London. A nameless woman, who does not have a clear and a known identity, can be read as a sign, illuminating the 'dialectical motifs' (Abrams 100) of London, in terms of gender (masculine and feminine) and space (inner and outer). Starting from above the ground, we have Wordsworth's

gaze as a male poet, which comes to feminise London into a Muse, as a sign of inspiration for a male author.

However, in the London Underground, we can see that Duffy's woman is a sign, which comes to represent 'nothing' - no name, no memory. Oscar Wilde's poem shows the best, when the two opposite pole meet - under the sun, in the middle of the crowd, the streets, colours, noises and sensations of London, there is this one cold, wet and heartless woman, who does not have an emotion, and who is impossible to be accessed and to be understood in an emotional way. Each poet, William Wordsworth, Oscar Wilde, and Carol Ann Duffy - all of them show the way in which Charles Baudelaire defines 'modernity' (Baudelaire 12), because each one of them depicts their own

impressions of London in their own fashion, combining the hardship of life in the hope of the smallest thing in the dialectical aesthetics of London.

Works Cited

Abrams, M. H. *The Mirror and the Lamp: Romantic Theory and the Critical Tradition*. New York: W. W. Norton, 1958.

Baudelaire, Charles. *The Painter of Modern Life and Other Essays*. London: Phaidon, 1995.

Bloom, Harold. *The Visionary Company: A Reading of English Romantic Poetry*. Ithaca: Cornell UP, 1983.

Day, Aidan. *Romanticism*. London: Routledge, 1996.

Ford, Mark, ed. *London: A History in Verse*. Cambridge, MA: Harvard University Press, 2012.

Hartman, Geoffrey H. 'Nature and the Humanization of the Self in Wordsworth'. *English Romantic Poets: Modern Essays in Criticism*. Ed. M. H. Abrams. Oxford: Oxford University Press, 1975.

Lin, Allison. *London Poetics*. Taipei: Showwe, 2016.

Nägele, Rainer. 'The Poetic Ground Laid Bare (Benjamin Reading Baudelaire). *Walter Benjamin: Theoretical Questions*. Ed. David S. Ferris. Stanford: Stanford University Press, 1996.

Olin, Margaret. 'Gaze'. *Critical Terms for Art History*. Eds. Robert S. Nelson and Richard Shiff. Chicago: The University of Chicago Press, 1992.Pollock, Griselda. *Vision & Difference: Femininity, Feminism and the Histories of Art.* London: Routledge, 1994.

Rubin, James H. *Impressionism*. London: Phaidon, 1999.

Scott, Clive. 'Streets, Buildings and the Gendered City'. *Street Photography: from Atget to Cartier-Bresson*. London: I. B. Tauris, 2007.'Sublime'. *Oxford Dictionary of Literary Terms*. Chris Baldick. 3rd ed. 2008. N. Abrams, 1995.

Spalding, Frances. *British Art Since 1900*. London: Thames and Hudson, 1996.

Thomson, Belinda. *Impressionism: Origins, Practice, Reception*. London: Thames & Hudson, 2000.

Tolson, Roger. 'Moore and the Machinery of War'. *Henry Moore: War and Utility*. London: Imperial War Museum, 2006.

Art and Narrative

· Chapter 3 ·

Realism

Introduction

Comparing to some other narrative forms such as
Impressionism or Surrealism, the term Realism comes to suggest
more elements of describing what one sees, rather than what one
feels. In this respect, a realistic narration is to be understood as

an observation and a representation of a kind of reality, which is created in a textual form.

Representing Reality

In his *Oxford Dictionary of Literary Terms*, Chris Baldick defines the term Realism as a way of 'writing that gives the impression of recording or "reflecting" faithfully an actual way of life', because this mode of writing is 'based on detailed accuracy of description' (Baldick 281). For instance, in his novel *Crime and Punishment*, Fyodor Dostoyevsky gives the readers a vivid textual representation, which comes to describe

a sequence of actions after Raskolnikov kills Alyona Ivanovna, as the readers can see the details of the elements of describing - including how he 'laid the axe on the ground near the dead body', how he took 'the key' out of 'her pocket', how to try 'not to get smeared with blood', so that he can work on fitting 'the keys into the chest' (Dostoyevsky 95). In this sequence of actions, the readers can see that somehow, realism, as a narrative style, can be defined as an art of describing.

In a literary text, even the most realistic representation has a slightest element of the imagery. It is simply because of the nature of language, as the signifier does not always signified the exact meaning. Or, when we are reading, our visualisation of the verbal narrative can somehow indicate the meanings between the

lines, and beyond the lines.

A visualisation of a narrative, say, as true as a photographic representation, in this respect, can have the imaginary in a realistic description. For example, in *The Old Curiosity Shop*, Charles Dickens's verbal portrayal of Little Nell is extremely 'vivid' (Underwood 91). Although it is descriptive, this character reveals the way in which the imagery stays in a 'fairy-like quality' of a girl, as she is 'so fair, with such blue veins and such a transparent skin, and such little feet' (Underwood 91).

Again, for example, in John Galsworthy's *The Man of Property*, the 'soft persuasive passivity' (Galsworthy 202) of Irene's face, somehow, in the eyes of the beholder Bosinney, with appreciation and love, has a 'sensuous purity' (Galsworthy

202) of Titian's painting. The way in which Galsworthy depicts Irene's face indicates the reality of 'beauty adorned' (Barolskey 25). Her beauty is the sacred and the 'naked truth' (Barolskey 25), with Bosinney's recognition.

If we want to analyse Jane Austen's *Pride and Prejudice* in terms of realism, including verbal representations and the artistic elements in them, for example, there are at least three research aspects to be focused. First of all, we can look into the material aspects in Austen's writing, as a Marxist critic would do, in order to see the way in which the sense of reality comes to construct the material world. Most of the time, the characters talk about marriage, money and property, just as the first sentence of the novel comes to show, as 'a truth universally acknowledged' - 'a

single man in possession of a good fortune must be in want of a wife' (Austen 5). This sentence directly depicts a kind of social reality, in which marriage needs to be proposed by a rich single man. As for a woman will take that proposal into consideration or not, which will depend on the social and the financial stability of a man.

Secondly, particularly in *Pride and Prejudice*, a character's sense of reality is illuminated through 'prejudice' - which is a kind of illusion created by misreading and misjudging people (although such a need of reading and judging people is based on an aim of another reality - marriage). The process of misreading and misjudging people, in a way, leads the characters to find the truth. Although it is not necessary to follow Tolstoy's exact way

of distinguishing a good work of art, or a bad work of art (as good women are mothers, and bad women are prostitutes, see Tolstoy 150), still, when the character finds his or her own true love, it proves that the process of misreading and misjudging is totally worth it. It feels just like seeing the beauty of a real work of art, with its 'authenticity' (Benjamin 220) and its 'aura' (Benjamin 221). We can certainly feel the aura of that work of art, through Benjamin's smoke. It is like Mr Darcy himself, in Chapter 7, looking at Elizabeth (after her long walk, coming to see her sister Jane), he sees something real in her not her dirty dress, but her courage and 'her complexion' (Austen 28).

Thirdly, in Austen's narrative, especially in *Pride and Prejudice*, we can tell that the way of depicting a character can

be termed as psychological realism, because in some ways, Austen's narrative makes the readers think about Henry James's Isabel, in *The Portrait of a Lady*. As Ian Watt claimed in his *The Rise of the Novel*, the readers would notice the importance of the 'psychological closeness to the subjective world of the characters' (Watt 297). In Jane Austen's novels, the readers can see that

there is usually one character whose consciousness is tacitly accorded a privileged status, and whose mental life is rendered more completely than that of the other characters. In *Pride and Prejudice* (published 1813), for example, the story is told Substantially from the point of view of Elizabeth Bennet, the heroine; but the

identification is always qualified by the other role of the narrator acting as dispassionate analyst, and as a result the reader does not lose his critical awareness of the novel as a whole (Watt 297).

Austen's Elizabeth Bennet is definitely the main character, although she is not Mrs Bennet's favorite daughter. And yet, I would argue that we can hardly say that 'the story is told substantially from the point of view of Elizabeth Bennet', as Watt claimed. In *Pride and Prejudice*, each character in the family is equally important. The whole novel represents a society, in a way which a woman's happiness is based on how effective her 'husband-hunting' business (Woolf 110) can be. It

seems to be very narrow, as a subject for a novel. And yet, the emotions of each character - happiness, sadness, and so on - as aspects of representing realism, come to balance each other's - such as husband and wife, father and daughters, mother and daughters, and among the daughters, creating the beauty of Austen's narrative.

Verbal Representations

In *Pride and Prejudice*, a realistic representation comes in a verbal form, which is a letter written by Mr Darcy. The best example would be this private letter in Chapter thirty-five, which

Mr Darcy wrote to Elizabeth. In the letter, Mr Darcy hoped to tell Elizabeth 'the truth' (Austen 155, 158) that she deserves to know, regarding her elder sister's relation with Bingley and Mr Wickham's personality. For Mr Darcy, this letter is 'a faithful narrative' (Austen 158), in a way which people, events, time, places and objects (including the amount of money) are clearly stated, in order to give Elizabeth a better understanding of who he really is.

Austen's way of dealing with 'the problem of reality' (Brown 233) can be seen in this particular verbal form, because for Elizabeth, Mr Darcy's letter certainly shows a kind of reality, in a way which she would know the truth, and she would realise her own feeling for Mr Darcy, as she had never found it before. The

'process of vision' that Henry James depicted so much in detail, in Isabel Archer in *The Portrait of a Lady*, known as psychological realism ('window of perception', in Lin 93), somehow can be seen as a further development of this initial personal reality, as 'the mind seeks when it wants truth' (Slattery 61).

In Harold Pinter's play, *The Birthday Party*, the readers can see another form of realism, in a way which language is used to possess nature, showing a real status of life rather than simply describe it directly. To have a birthday party for Stanley is Maggie's way of personalizing her female nature, in verbal forms, as she did not physically give birth to Stanley. Also, the date she chose was not his birthday. And yet, because of Maggie's desire of personalizing nature, after the birthday

party, Stanley has a symbolic rebirth, by physically leaving the boarding house, which shows the subversion of social codes, in the realm of semiotics.

Again, the personification of nature comes to define and to highlight realism not only as a methodology of literary writing, but also as a sign of social code. In Pinter's *The Birthday Party*, Mccann and Goldberg can be seen as two strangers who are, in Walter Benjamin's sense in his essay 'The Storyteller: Reflections on the Works of Nikolai Leskov' - two storytellers, mastering the 'craftsmanship' of 'storytelling' (Benjamin 92). Both of them come from an unknown place, travel to Maggie's boarding house. They seem to be able to verbally construct Stanley's mysterious past. And yet, after that fake birthday party

of Stanley's, in Act Three, these two storytellers come out with even more skillful verbal seductions, trying to take Stanley away from Maggie's boarding house, as

> *[t]hey begin to woo him, gently and with relish. During the following sequence* Stanley *shows no reaction. He remains, with no movement, where he sits.*

Mccann. Out of our own pockets.

Goldberg. It goes without saying. Between you and me, Stan, it's about time you had a new pair of glasses.

Mccann. You can't see straight.

Goldberg. It's true. You've been cockeyed for years.

Mccann. Now you're even more cockeyed.

Goldberg. He's right. You've gone from bad to worse.

Mccann. Worse than worse.

Goldberg. You need a long convalescence.

Mccann. A change of air.

Goldberg. Somewhere over the rainbow.

Mccann. Where angels fear to tread.

Goldberg. Exactly.

Mccann. You're in a rut.

Goldberg. You look anaemic.

Mccann. Rhenmatic.

Goldberg. Myopic.

Mccann. Epileptic.

Goldberg. You're on the verge.

Mccann. You're a dead duck.

Goldberg. But we can save you.

Mccann. From a worse fate.

Goldberg. True.

Mccann. Undeniable.

Goldberg. From now on, we'll be the hub of your wheel.

Mccann. We'll renew your season ticket.

Goldberg. We'll take tuppence off your morning tea.

Mccann. We'll give you a discount on all inflammable goods.

Goldberg. We'll watch over you.

Mccann. Advice you.

Goldberg. Give you proper care and treatment.

Mccann. Let you use the club bar.

Goldberg. Keep a table reserved.

Mccann. Help you acknowledge the fast days.

Goldberg. Bake you cakes.

Mccann. Help you kneel on kneeling days.

Goldberg. Give you a free pass.

Mccann. Take you for constitutionals.

Goldberg. Give you hot tips.

Mccann. We'll provide the skipping rope.

Goldberg. The vest and pants.

Mccann. The ointment.

Goldberg. The hot poultice.

Mccann. The fingerstall.

Goldberg. The abdomen belt.

Mccann. The ear plugs.

Goldberg. The baby powder.

Mccann. The back scratcher.

Goldberg. The spare tyre.

Mccann. The stomach pump.

Goldberg. The oxygen tent.

Mccann. The prayer wheel.

Goldberg. The plaster of Paris.

Mccann. The crash helmet.

Goldberg. The crutches.

Mccann. A day and night service.

Goldberg. All on the house.

Mccann. That's it.

Goldberg. We'll make a man of you.

Mccann. And a woman.

Goldberg. You'll be re-orientated.

Mccann. You'll be rich.

Goldberg. You'll be adjusted.

Mccann. You'll be our pride and joy.

Goldberg. You'll be a mensch.

Mccann. You'll be a success.

Goldberg. You'll be integrated.

Mccann. You'll give orders.

Goldberg. You'll make decisions.

Mccann. You'll be a magnate.

Goldberg. A statesman.

Mccann. You'll own yachts.

Goldberg. Animals.

Mccann. Animals (Pinter 92 - 94).

Although the above is a long quotation, we can examine the dialogue between these two 'storytellers' in a more specific way. After all kinds of verbal seduction and promise of Stanley's rebirth (change the glasses, renew, re-orientated), Mccann and Goldberg conclude their verbal construction of this symbolic parenting (involving the baby powder, all day services) with the word 'animals' - as comic and as shocking, if Stanley would have his yachts and would become the statesman.

The whole act of verbal construction comes to represent a perfect vision - a brilliant picture of Stanley's future. It is a whole process of being reborn, in a way which the word 'animals' comes to indicate the long and harsh process of natural selection and evolution, as all animals come into their own perfect shape for survival. Although Stanley's 'fog of self-fakery' (Luckhurst 108) is, in a way, destroyed by the two strangers' verbal construction of a perfect picture for the future, at least it is the beginning of the whole process of being symbolically reborn.

The word 'Animals' in the discourse of Goldberg and Mccann would not be such a shock to the audience and the readers, if there was not any 'hidden subtext' (Merritt 137) as Susan Hollis Merritt terms it in her book chapter - 'Some Other

Language Games: Linguistic Parlays and Parleys'. I would suggest, both linguistically and dramatically, the word comes effectively to bring a very comic subversion of Stanley's dull and somehow melancholically trapped daily life, indicating that he would need not only a symbolic birthday party, but to have leave Maggie's house as a way to get rid of this madness. To be symbolically reborn, for Stanley, is to have a feeling of freedom which is just like an animal. The meaning of Stanley's re-birth comes very close to Foucault's term in his book, *Madness & Civilization*. This new status means that Stanley will be free from fear or anxiety, by letting his 'animality' (Foucault 74) out for a change.

Visual Representations

The best example of Austen's realism in the form of visual representation would be the portrait of Mr Darcy in the picture-gallery in Pemberley. For sure, Elizabeth knows what Mr Darcy looks like. And yet, the smile on his portrait is a significant feature, which Elizabeth knows by heart, as the portrait itself is 'a striking resemblance of Mr Darcy, with such a smile over the face as she remembered to have sometimes seen when he looked at her' (Austen 191).

Mr Darcy's smile works like an epiphany for Elizabeth, as

she looks at the picture. Through her gaze, at that right moment, she feels

a more gentle sensation towards the original than she had ever felt in the height of their acquaintance. The commendation bestowed on [Mr Darcy] by Mrs Reynolds was of no trifling nature. What praise is more valuable than the praise of an intelligent servant? As a brother, a landlord, a master, she considered how many people's happiness were in his guardianship! - how much of pleasure or pain it was in his power to bestow! - how much of good or evil must be done by him! Every idea that had been brought forward by the housekeeper was

favourable to his character, and as she stood before the canvas on which he was represented, and fixed his eyes upon herself, she thought of his regard with a deeper sentiment of gratitude than it had ever raised before; she remembered its warmth, and softened its impropriety of expression (Austen 191 - 192).

The above paragraph reveals the way in which Elizabeth's thought and memory work with the visual object (the canvas of Mr Darcy), through the gaze. The eyes of Mr Darcy seem to be 'fixed upon her' (Austen 192). Gazing back, responding Elizabeth's own emotions and feelings of love and being 'graceful' (Allen 37) aroused by her own gaze, Mr Darcy reveals

himself in the portrait, as 'a good-tempered man' and 'the most generous-hearted' (Austen 190) in Elizabeth's mind. That is a very different impression from what she received in 'the evening dance at Netherfield' (Austen 153), as Mr Darcy was so much 'misrepresented in dialogue' (Lacour 616) then. Elizabeth's epiphany, in a way, is produced through her own gaze. Her gaze refers to a deeper meaning of realism, evoking a true feeling of love. This awakening indicates the way in which 'the force of love' (Amis 89) comes from a real understanding of the beloved person, instead of coming from some sexual passion. This is the essence of the Austenian 'insight into life' (Poggioli 44), as the readers can learn from her characters and the visual representations.

In some literary texts, the meaning of realism has a stronger social perspective. The readers can see a textual representation of a particular society, in which it comes to remind the readers that even human nature sometimes comes to indicate desires which cannot be fulfilled, love can still reveal a coded world of culture and symbols, in a way which different layers of social reality are represented through visual objects and figures, as Edith Wharton reminds us in her *The Age of Innocence*.

As I want to find out the truth - about Newland's secret love, I realise that it would only be revealed by 'the level of reality' (Bowlby 2007, 205) through the characters in the old New York society. Newland Archer feels that he knows May, but he does not 'understand' Ellen (Wharton 1995, 141), because

both women come to represent two different kinds of social reality. That is the reason why Newland needs to idealise Ellen in his mind, in order to keep her as a sort of inner reality, which belongs to him. The outer reality is dominated by May, as the old New York society would show in the early 1870s. It is not only a world of nostalgic and abstract, but also 'ironical and tender' (Lee 561), as it is full of social meanings in terms of reading a textual world of reality.

Wharton's realism can be seen in two aspects. Firstly of all, it is a more like a kind of literary style which depicts the visible world in detail. For instance, the way of 'telling detail - the cut of Ellen Olenska's dress at the opera', (Finzi 29) as Penelope Vita-Finzi claims in *Edith Wharton and the Art of Fiction*.

Ellen's Europe is a visible world of 'publicity, luxury, and glamor' (Montgomery 133). In the novel, that world is depicted by Ellen herself, as a world of visual displays, which is for her, comes to represent 'hell' - 'on the material side' (Wharton 1995, 131). Among other things, '[j]ewels - historic pearls' (Wharton 1995, 131) are definitely the centre pieces of display, as the readers can see in David Bailly's *Still Life* (1651, in Alpers 104). Visual objects are used to represent the process of understanding the world. The painting shows the viewers a 'description' (Alpers 109) of 'a catalogue: wood, paper, glass, metals, stone, plaster, clay, bone, hide, earthenware, pearls, petals, water, smoke, and paint' (Alpers 103). Through this painting, the readers can see that Ellen, as a woman, is seen as an object for display in

Europe. Although there is no further description about that visible world, somehow, she is fully aware of that, as the readers can see the way she feels about being in that world - a world that she was trying to escaped from.

Secondly, to read realism in Wharton's own term, the readers can see that realism is used and recognised more like a writing technique, in order to 'see life whole' (Wharton 1925, 64), which is shown through an artistic 'atmosphere' (Wharton 1925, 64). In the novel, these two aspects of realism are expressed in Newland Archer's life - as the first one shows the way in which he looks at the visible world, and the second one indicates how he constructs an inner reality, which is true and real to him, in terms of the meaning of love and marriage.

For Newland, marrying May is a conscious and preferable choice, because May

had fulfilled all that he had expected. [...]. As for the momentary madness which had fallen upon him on the eve of his marriage, he had trained himself to regard it as the last of his discarded experiments. The idea that he could ever, in his senses, have dreamed of marrying the Countess Olenska had become almost unthinkable, and she remained in his memory simply as the most plaintive and poignant of a line of ghosts (Wharton 1995, 168).

As Newland cannot marry Ellen, everything about her is

more real in his mind. Ellen, physically in the visible world, is away from him. They cannot be together, because it is socially unacceptable, in terms of the world of old New York.

Ellen's absence, as a part of Newland's psychological status, makes him feel 'more real' (Wharton 1995, 284) to him. If he goes upstairs to see Ellen, in Paris, he would be feeling like looking at a fake painting, (or a reproduction of a work of art), simply because of the 'rich atmosphere' (Wharton 1995, 282) - the aura of Newland's inner reality - would be gone. Newland can only 'gaze at' (Wharton 1995, 283) Ellen's balcony, and 'pictur[e]' (Wharton 1995, 283) the way in which Ellen would be in his mind. Newland's mental picture of Ellen comes to reveal a status of his reality, as his gaze represents a status which is more

real than the visuality.

Ellen's figure, although visually available to Newland, represents something that he can never reach, as long as he is in the context of old New York's social reality. Only when the visual turns into the inwardness, Newland is able to hold on to the mental image. By doing so, he can keep living as the way in which the old New York society accepts - such as 'a kind of innocent family hypocrisy' (Wharton 1995, 274). May's first photo shows that for Newland, she represents something, which feels just like the old New York itself - 'so lack of imagination, so incapable of growth, that the world of her youth had fallen into pieces and rebuilt itself without her ever being conscious of the change' (Wharton 1995, 274). Newland is someone who fits

in - as 'a good citizen' (Wharton 1995, 273). In old New York, it takes someone like Newland to show that marriage is not only 'a dull duty' (Wharton 1995, 273), but an art of keeping 'the dignity of a duty' (Wharton 1995, 273).

Through representing two types of women, Edith Wharton depicts her dual realism - one is Newland's 'actual life' (Wharton 1995, 210), representing through May, 'in the house' (Wharton 1995, 74); the other is Newland's 'real life' (Wharton 1995, 210), representing through Ellen, 'a kind of sanctuary' (Wharton 1995, 210) that is 'within himself' (Wharton 1995, 210). The more Newland's reality goes toward the inwardness, the more that reality would escape from the realm of a simple and a direct description of the visible world. It will become more symbolic,

in a way in which symbolism would show, as the readers can see in the next chapter.

Conclusion

In this chapter I explore two different types of realism through reading a few narrative forms as textual representations. First of all, in some writings, one type of realism comes from the visible world. Secondly, in some other writings, another type of realism comes from language. Although these two literary forms have a different focus in terms of certain ways of depicting the way in which what reality means, both types of realism,

as I would argue in this research, would show the readers the real status of life of the characters, as they are in their textual representive worlds.

Works Cited

Allen, Dennis W. *Sexuality in Victorian Fiction*. Norman: University of Oklahoma Press, 1993.

Alpers, Svetlana. *The Art of Describing: Dutch Art in the Seventeenth Century*. Chicago: The University of Chicago Press, 1983.

Amis, Martin. 'Force of Love: *Pride and Prejudice* by Jane Austen'. *A Truth Universally Acknowledged: 33 Reasons Why We Can't Stop Reading Jane Austen'*. Ed. Susannah Carson. London: Penguin, 2009.

Austen, Jane. *Pride and Prejudice*. London: Penguin, 1994.

Barolskey, Paul. 'Sacred and Profane Love'. *Source: Notes in the History of Art* 17.3 (1998): 25 - 28.

Benjamin, Walter. *Illuminations: Essays and Reflections*. Ed. Hannah Arendt. Trans. Harry Zohn. New York: Schocken, 1968.

Bowlby, Rachel. *Freudian Mythologies: Greek Tragedy and Modern Identities*. Oxford: Oxford University Press, 2007.

Brown, Marshall. 'The Logic of Realism: A Hegelian Approach'. *PMLA* 96.2 (1981): 224 - 241.

Dostoyevsky, Fyodor. *Crime and Punishment*. Ed. Cynthia Brantley Jobnson. New York: Simon & Schuster, 2004.

Foucault, Michel. *Madness & Civilization: A History of Insanity in the Age of Reason*. Trans. Richard Howard. New York: Vintage, 1988.

Galsworthy, John. *The Man of Property*. Hertfordshire: Wordsworth, 1994.

Knights, Pamela. 'Forms of Disembodiment: The Social Subject in *The Age of Innocence*'. *The Cambridge Companion to Edith Wharton*. Ed. Millicent Bell. Cambridge: Cambridge University Press, 1995.

Lacour, Claudia Brodsky. 'Austen's *Pride and Prejudice* and Hegel's "Truth in Art": Concept, Reference, and History'. *ELH* 59.3 1992): 597 - 623.

Lee, Hermione. *Edith Wharton*. London: Chatto & Windus, 2007.

Lin, Tzu Yu Allison. 'Self, Art, Fiction: *The Portrait of a Lady*'. *A Moment of Joy: Essays on Art, Writing, and Life*. Taipei: Showwe, 2014.

Luckhurst, Mary. 'Speaking out: Harold Pinter and Freedom of Expression'. *The Cambridge Companion to Harold Pinter*. Ed. Peter Raby. Cambridge: Cambridge University Press, 2009.

Merritt, Susan Hollis. *Pinter in Play: Critical Strategies and the Plays of Harold Pinter*. Durham, NC: Duke University Press, 1995.

Montgomery, Maureen E. *Displaying Women*. London: Routledge: 998.

Penelope, Vita-Finzi. *Edith Wharton and the Art of Fiction*. New York: St. Martin's, 1990.

Pinter, Harold. *Plays: One*. London: Methuen, 1983.

Poggioli, Renato. 'Dostoevski and Western Realism'. *The Kenyon Review* 14.1 (1952): 43 - 59.

'Realism'. *Oxford Dictionary of Literary Terms*. Chris Baldick.
3rd ed. 2008.

Slattery, Mary Francis. 'What is Literary Realism'? *The Journal of Aesthetics and Art Criticism*. 31.1 (1972): 55 - 62.

Tolstoy, Leo. *What is Art?* Trans. Richard Pevear and Larissa Volokhonsky. London: Penguin, 1995.

Underwood, Hilary. 'Dickens Subjects in Victorian Art'. *Dickens and the Artists*. Ed. Mark Bills. New Haven: Yale University Press, 2012.

Watt, Ian. *The Rise of the Novel*. London: Pimlico, 2000.

Wharton, Edith. *The Writing of Fiction*. London: Charles Scribner's Sons, 1925.

---. *The Age of Innocence*. Cambridge: Cambridge University Press, 1995.

Woolf, Virginia. *Women and Writing*. Ed. Michèle Barrett. Orlando: Harcourt Barce, 1979.

· Chapter 4 ·

Symbolism

Professor Terry Eagleton, in his book *Literary Theory: An Introduction*, mentioned about 'the French nineteenth-century Symbolist poets' (Eagleton 140) in the context of *Writing Degree Zero* of Roland Barthes. The thing is, Barthes did not use an example (at least not a particular French Symbolist one) to demonstrate the differences between 'classical' literature and 'modern poetry' (Barthes 53). Moreover, at the first glance, the

readers also do not know the reason - why this kind of 'poetic mode of writing' (Barthes 56) - the writing about 'the object' (Barthes 56), can be named as 'zero degree' (Barthes 54)?

For sure, Eagleton confirms the meaning of the Symbolic mode of poetic writing, as writing itself is 'an end and a passion in itself' (Eagleton 140), as many critics would feel about the work of the French poet Stéphane Mallarmé, as if writing itself is a sort of 'haunting obsession' (Mallarmé 163). Later, in Susan Sontag's 'Writing Itself: On Roland Barthes', the readers can, in a way, realise that the French example of 'zero degree' is indeed, to be visualised in 'the Eiffel Tower', as it is a kind of 'monument', which can be useful 'as a sign' (Sontag 437). The Tower is somehow 'pure - virtually empty', which can '*mean*

everything' (Sontag 437).

An object can look as empty as it is, and yet, it means everything, just like the lighthouse in Lily Brisco's painting. In a capitalist society, people can be treated as 'things' (Barry 157). It does not matter - a person, a figure, a colour, a shape, or an object - all things can be some kind of potential signs - that is somehow a Symbolist's way of seeing the visible world, as personal feelings shall be advocated 'through the use of private symbols' (Baldick 327).

What is a symbol, in a literary text, or in a work of art? The definition of this can be more than one, which depends on the writer's or the artist's use of a colour, a figure, a shape, a gesture, and so on. The only thing which is the same - that is - a symbol is

a personal choice, which comes to represent a personal emotion. For example, a colour in John Ruskin's aesthetics would have a suggestive meaning, as 'the intensity of the sky's blue' can be seen as 'the tribute paid to God' (Gibson 63). Also, as Suzanne M. Singletary claims, a gesture such as wrestling, is able to 'symbolizes the defense of truth against falsity, a steppingstone towards regeneration' (Singletary 304). Light can be seen as an allegory, comes to symbolise the triumph of goodness, truth and the real, as Jack F. Stewart has suggested, that light 'is equated with the spirit' (Stewart 378), as a symbol of one's true self, 'the creative force', and 'cosmic energy' (Stewart 378). Darkness, on the other hand, can be seen as the evil, the false, and the unreal.

The image of Paris is expressed through a symbol of an evil flower. But it is not all. The city itself also comes to symbolise several things which are beyond the spaces and the buildings - as 'each human type' comes to create 'the physiology of the city' - '*Paris la nuit, Paris à table, Paris dans l'eau, Paris à cheval, Paris pittoresque, Paris marié* (Benjamin, *Selected Writings* 18).

Baudelaire's poems, in Benjamin's writing in the context of a capitalist society, for example, have symbolic meanings, in a way which they come to show the poet's personality with a strong emotional intensity. The figure of the flâneur is indeed, a symbol of very strong passion for writing and for observing the city. The more we follow Baudelaire's symbols in his work, the more we can see this intense emotion which comes to feel and to

respond to the external visible world.

The physiologies of Paris come to show that the city is, symbolically, the flâneur, the arcade, the street - all these are a part of the city as a whole. Although the figure of the flâneur comes originally from Poe's short story, 'The Man of the Crowd' - a 'narrator is a man in London' (Benjamin, *Illuminations* 170), and yet, the flâneur would need to give thanks to the city of Paris, for the city makes the figure a significant one, particularly with socially symbolic meanings.

The leisure of looking, strolling and the power of imagination come to construct the flâneur as a symbolic figure. Here, the readers can also see that in Benjamin's 'The Paris of the Second Empire in Baudelaire', for the flâneur, the street of

Paris 'becomes a dwelling place', as 'he is as much at home among house façades as a citizen is within his four walls' (Benjamin, *Selected Writings* 19). Also, for the flâneur, in the city, everything has a symbolic meaning. For example, the walls of buildings

are desk against which he presses his notebooks; news-stands are his libraries; and café terraces are the balconies from which he looks down on his household after his work is done. That life in all its variety and inexhaustible and against the gray background of despotism was the political secret of the literature to which the physiologies belonged (Benjamin, *Selected Writings* 19).

In 'the sociology of a big city' (Benjamin, *Selected Writings* 19), the flâneur celebrates life mainly through the visual, as a part of the sensual experiences. As David Frisby suggests, the poet Baudelaire's gaze is, in a way allegorical, which comes to turn Paris into an 'object' (Frisby 33). The flâneur, in this context, is having a socially symbolic function, in a way which all objects, figures, colours and things he sees are to give new meanings to define 'the *age*' (Sartre 234) - the 'modernity' in Baudelaire's own term (Baudelaire 12).

A city is like a readable text. In Professor Rachel Bowlby's book, *Talking Walking: Essays in Cultural Criticism,* for example, she suggests that to read a city is 'a practice of

decoding' (Bowlby 29). Michael Gibson comes to define the meaning of a 'symbol' as it 'refers to an absent reality' (Gibson 21), in a way which a symbol does have the capacity to say something 'beyond itself' (Gibson 27), so that we have something to be decoded. The city of London, in this respect, is also somehow 'readable' (Bowlby 28). And yet, in the eyes of the poet, it is still a city of 'unknowable', which is filled with symbols of '[u]ninterpretability' (Bowlby 29), as the crowd and the blind Beggar would show.

In T. S. Eliot's *The Waste Land*, London is a symbol of 'unreal city' (Ford 511). How come a place can be so real (full of colours, figures, shapes and so on), and yet, can be denied by a poet in a symbolic term? The word 'unreal' is indeed, comes

to reinforce the true existence of London as a city. To name a city as 'unreal' - it somehow has a symbolic meaning of a city of darkness, ugliness, and degeneration.

The symbols of good and evil come to construct a 'network of associations' (Olds 156), giving Eliot's city of London the meaning of its *age*, as in Sartre's term, and as the readers can see in Baudelaire's Paris. This particular network of senses (as in Baudelaire and in Eliot), memory and imagination (as in Mallarmé and in Proust), in a way, comes to create the symbolic value of the poetic form, again, in order to give an allegorical meaning through narrative - specifically visually and verbally - as the network of symbols works in a suggestive way. It is to 'invoke speculative doubt rather than analytic certainly' (Olds

157). It is love, which can overcome the dialectics of the good ('le bien') and the evil ('le mal').

Art and Narrative

· Appendix ·

Shelly, 'Peter Bell the Third'

I

Hell is a city much like London -

A populous and a smoky city;

A populous and a smoky city;

There are all sorts of people undone,

And there is little or no fun done;

 Small justice shown, and still less pity.

II

There is a Castles, and a Canning,

 A Cobbett, and a Castlereagh;

All sorts of caitiff corpses planning

All sorts of cozening for trepanning

 Corpses less corrupt than they.

III

There is a ***, who has lost

His wits, or sold them, none knows which;

He walks about a double ghost,

And though as thin as Fraud almost -

Ever grows more grim and rich.

IV

There is a Chancery Court; a king;

A manufacturing mob; a set

Of thieves who by themselves are sent

Similar thieves to represent;

An army; and a public debt.

V

Which last is a scheme of paper money,

And means - being interpreted -

"Bees, keep your wax - give is the honey,

And we will plant, while skies are sunny,

Flowers, which in winter serve instead."

VI

There is a great talk of revolution -

And a great chance of despotism -

German soldiers - camps - confusion -

Tumults - lotteries - rage - delusion -

Gin - suicide - and methodism;

VII

Taxes too, on wine and bread,

 And meat, and beer, and tea, and cheese,

From which those patriots pure are fed,

Who gorge before they reel to bed

 The tenfold essence of all these.

.....

IX

Lawyers - judges - old hobnobbers

Are there - bailiffs - chancellors -

 Bishops - great and little robbers -

Rhymesters - pamphleteers - stock-jobbers -

　Men of glory in the wars, --

X

Things whose trade is, over ladies

　To lean, and flirt, and stare, and simper,

Till all that is divine in woman

Grows cruel, courteous, smooth, inhuman,

　Crucified 'twist a smile and a whimper.

(Benjamin, *Arcade* 449 - 450)

Baudelaire, 'À une passante'

La rue assourdissante autour de moi hurlait.

Longue, mince, en grand deuil, douleur majestueuse,

Une femme passa, d'une main fastueuse

Soulevant, balançant le feston et l'ourlet;

Agile et noble, avec sa jambe de statue,

Moi, je buvais, crispé comme un extravagant,

Dans son oeil, ciel livide où germe l'ouragan,

La douceur qui fascine et le plaisir qui tue.

Un éclair … puis la nuit! - Fugitive beauté

Dont le regard m'a fair soudainement renaitre,

Ne te verrai-je plus que dans l'éternité?

Ailleurs, bien loin d'ici! Trop tard! *Jamais* peut-être!

Car j'ignore où tu fuis, tu ne sais où je vais,

O toi que j'eusse aimée, ô toi qui le savais!

(Benjamin, *Illuminations* 168 - 169)

Works Cited

Barry, Peter. *Beginning Theory: An Introduction to Literary and Cultural Theory*. Manchester: Manchester University Press, 1995.

Barthes, Roland. *Writing Degree Zero & Elements of Semiology*. Trans. Annette Lavers and Colin Smith. London: Vintage, 2010.

Baudelaire, Charles. *The Painter of Modern Life and Other Essays*. Trans. Jonathan Mayne. London: Phaidon, 1995.

Benjamin, Walter. *Illuminations*. Trans. Harry Zohn. New York: Schocken, 1968.

---. *The Arcades Project*. Trans. Howard Eiland and Kevin MeLaughlin. Cambridge, MA: Harvard University Press, 2002.

---. *Selected Writings Volume 4, 1938 - 1940*. Trans. Edmund Jephcott, et al. Eds. Howard Eiland and Michael W Jennings. Cambridge, MA: Harvard University Press, 2006.

Bowlby, Rachel. *Talking Walking: Essays in Cultural Criticism*. Brighton: Sussex Academic Press, 2018.

Eagleton, Terry. *Literary Theory: An Introduction*. Oxford: Blackwell, 1995.

Frisby, David. *Cityscapes of Modernity*. Cambridge: Polity, 2001.

Ford, Mark, ed. *London: A History in Verse*. Cambridge, MA: Harvard University Press, 2012.

Gibson, Michael. *Symbolism*. London: Taschen, 2006.

Mallarmé, Stephané. *Collected Poems: A Bilingual Edition.* Trans. Henry Weinfield. Berkeley: University of California Press, 1996.

Olds, Marshall C. 'Literary Symbolism'. *A Companion to Modernist Literature and Culture.* Eds. David Bradshaw and Kevin J. H. Dettmar. Oxford: Blackwell, 2006.

Sartre, Jean-Paul. *What is Literature?* Trans. Bernard Frechtman. London: Methuen, 1978.

Singletary, Suzanne M. 'Jacob Wrestling with the Angel: A Theme in Symbolist Art'. *Nineteenth-Century French Studies* 32.3/4 (2004): 298 - 315.

Sontag, Susan. *A Susan Sontag Reader*. Middlesex: Penguin, 1982.

Stewart, Jack F. 'Light in *To the Lighthouse'*. *Twentieth Century Literature* 23.3 (1977): 377 - 389.

'Symbolists'. *Oxford Dictionary of Literary Terms.* Chris Baldick.
s3^rd ed. 2008.

語言文學類　PG2303　文學視界107

Art and Narrative

作　　　者 / 林孜郁（Tzu Yu Allison Lin）
責任編輯 / 徐佑驊
圖文排版 / 楊家齊
封面設計 / 蔡瑋筠

發 行 人 / 宋政坤
法律顧問 / 毛國樑　律師
出版發行 / 秀威資訊科技股份有限公司
　　　　　114台北市內湖區瑞光路76巷65號1樓
　　　　　電話：+886-2-2796-3638　傳真：+886-2-2796-1377
　　　　　http://www.showwe.com.tw
劃撥帳號 / 19563868　戶名：秀威資訊科技股份有限公司
　　　　　讀者服務信箱：service@showwe.com.tw
展售門市 / 國家書店（松江門市）
　　　　　104台北市中山區松江路209號1樓
　　　　　電話：+886-2-2518-0207　傳真：+886-2-2518-0778
網路訂購 / 秀威網路書店：https://store.showwe.tw
　　　　　國家網路書店：https://www.govbooks.com.tw

2019年8月　BOD一版
定價：200元
版權所有　翻印必究
本書如有缺頁、破損或裝訂錯誤，請寄回更換

讀 者 回 函 卡

感謝您購買本書，為提升服務品質，請填妥以下資料，將讀者回函卡直接寄回或傳真本公司，收到您的寶貴意見後，我們會收藏記錄及檢討，謝謝！
如您需要了解本公司最新出版書目、購書優惠或企劃活動，歡迎您上網查詢或下載相關資料：http:// www.showwe.com.tw

您購買的書名：_____

出生日期：_____年_____月_____日

學歷：□高中 (含) 以下　　□大專　　□研究所 (含) 以上

職業：□製造業　□金融業　□資訊業　□軍警　□傳播業　□自由業
　　　□服務業　□公務員　□教職　　□學生　□家管　□其它_____

購書地點：□網路書店　□實體書店　□書展　□郵購　□贈閱　□其他

您從何得知本書的消息？

　□網路書店　□實體書店　□網路搜尋　□電子報　□書訊　□雜誌
　□傳播媒體　□親友推薦　□網站推薦　□部落格　□其他_____

您對本書的評價：（請填代號　1.非常滿意　2.滿意　3.尚可　4.再改進）

　封面設計____　版面編排____　內容____　文／譯筆____　價格____

讀完書後您覺得：

　□很有收穫　□有收穫　□收穫不多　□沒收穫

對我們的建議：_____

11466

台北市內湖區瑞光路 76 巷 65 號 1 樓

秀威資訊科技股份有限公司 收

BOD 數位出版事業部

⋯⋯⋯⋯⋯⋯⋯⋯⋯⋯⋯⋯⋯⋯⋯⋯⋯⋯⋯⋯⋯⋯⋯⋯⋯⋯⋯⋯⋯⋯⋯

（請沿線對折寄回，謝謝！）

姓　　名：＿＿＿＿＿＿＿＿＿　年齡：＿＿＿＿　性別：□女　□男

郵遞區號：□□□□□

地　　址：＿＿＿＿＿＿＿＿＿＿＿＿＿＿＿＿＿＿＿＿＿＿＿＿

聯絡電話：(日)＿＿＿＿＿＿＿＿＿＿(夜)＿＿＿＿＿＿＿＿＿＿

E-mail：＿＿＿＿＿＿＿＿＿＿＿＿＿＿＿＿＿＿＿＿＿＿＿＿